HAIDA GWAII

QUEEN CHARLOTTE ISLANDS

Land of Mountains, Mist and Myth

Photographs by George Fischer

Introduction by Andrew Merilees

NIMBUS
PUBLISHING

Copyright © 2006 George Fischer
Introduction © 2006 Andrew Merilees

All rights reserved. No part of this book may be reproduced, stored in a retrieval system or transmitted in any form or by any means without the prior written permission from the publisher, or, in the case of photocopying or other reprographic copying, permission from Access Copyright, 1 Yonge Street, Suite 1900, Toronto, Ontario M5E 1E5.

Nimbus Publishing Limited
PO Box 9166
Halifax, NS B3K 5M8
(902) 455-4286

Printed and bound in Singapore

Design: Kate Westphal, Graphic Detail Inc., Charlottetown, P.E.I.

Library and Archives Canada Cataloguing in Publication

Fischer, George, 1954-
Haida Gwaii, Queen Charlotte Islands : land of mountains, mist and myth / photographs by George Fischer ; with an introduction by Andrew Merilees.

ISBN 1-55109-568-8

1. Queen Charlotte Islands (B.C.)—Pictorial works. I. Title.

FC3845.Q3F57 2006 971.1'1205'0222 C2005-907808-1

We acknowledge the financial support of the Government of Canada through the Book Publishing Industry Development Program (BPIDP) and the Canada Council, and of the Province of Nova Scotia through the Department of Tourism, Culture and Heritage for our publishing activities.

DEDICATION

I dedicate this book to all my friends at the West Coast Fishing Club – Brian Grange, Brian Legge, Rick Grange, Lisa Winbourne, Terry Cowan and all the staff who treated me and my assistant, Jean, like we were members of their fishing family. Thank you for showing me the beauty of your home.
—George Fischer

My contribution to this book is dedicated to my father, Bill Merilees, for introducing these islands, and their natural history to me at an early age, to my partner, Kimiko von Boetticher, for her assistance with this project and her role in my settling here, and to the generous and warm people of the Islands, particularly of Old Massett, who welcomed us, educated us and allow us to be witness to the vibrancy and community of this place.
—Andrew Merilees

ACKNOWLEDGEMENTS

This book would not have been made possible if it were not for the support, commitment and dedication of the West Coast Fishing Club. Brian Grange, Rick Grange, and Brian Legge—the owners of the resort—made it possible for me to access areas of the Queen Charlotte Islands-Haida Gwaii by boat, helicopter and Hummer. I would also like to express my gratitude to Andrew Merilees and Kimiko von Boetticher of Northwest Recreation Services in Masset; they supplied me with accommodations, transportation and helpful advice on all aspects of their community and Island.

On the front cover: A colourful face on one of the six new totem poles erected at the Qay'llnagaay Heritage Centre in Skidegate to honour six Haida villages devastated by smallpox during the twentieth century.

On the back cover: Crashing surf on the west coast of Graham Island near Tian Head.

Map credit: Catherine Barker

HAIDA GWAII

Queen Charlotte Islands

HAIDA GWAII · Queen Charlotte Islands

The steaming, medicinal thermal pools of Hotsprings Island in Juan Perez Sound are an ideal spot after a day of exploring the Gwaii Haanas National Park, Reserve and Haida Protected Site.

Graham Island is speckled with hundreds of lakes, including this heart-shaped one hemmed in by a luxuriant growth of green forest.

Almost twenty-five years ago the Queen Charlotte Islands provided me with the setting for an experience I will never forget. A memorable two-week natural history field trip that included crossing rough water, anchoring in sheltered bays and secluded inlets, discovering plentiful fish (my first salmon), abundant wildlife, vast wilderness, and huge trees. Most moving was coming upon the remains of the ancient and uninhabited Haida villages—the area destined to become a national park, protected area, and house a world heritage site.

Now, as a resident, I am reminded of my initial experiences almost daily. The natural scenery, re-emerging Haida culture, and evidence of the trials of European settlement make this a place with opportunities for investigation and discovery of many aspects of the region's history. A place of great beauty and rugged wilderness, the islands are the reward for anyone who adventures to the edge of the world.

GEOGRAPHY

Situated in isolation off the west coast of British Columbia, the Queen Charlotte Islands—recognized increasingly as Haida Gwaii (Islands of the People)—occupy a unique location in world geography. The most remote archipelago in Canada, the Queen Charlottes comprise about 150 individual islands of various sizes lying alongside the edge of the continental shelf. Here, within only a few kilometres of land, the ocean floor drops from a hundred to more than a thousand metres and provides an upwelling of currents rich in marine life. From here, the Pacific Ocean lies uninterrupted until breaking on the shores of Japan.

Consisting of materials hundreds of millions of years old, the Islands found their current geographic location about twenty million years ago and have undergone several geological transformations and adaptations since the beginning of time. Plate tectonics, seismic activity, glacial erosion, and a continuously changing sea level have all contributed to the development of the present landscape.

Similar to many of the landscapes found on mainland British Columbia, the islands include alpine mountains, subalpine plateaus, forest plains, and muskeg bogs. While they share characteristics with the rest of the province, the islands are also home to about forty unique species or subspecies of plants and animals. It is through this concentration of diversity that the islands have come to be known as the Galapagos of the North.

Much of this uniqueness has been explained through the theory that the islands served as a refugium, or place of escape, from the last Ice Age, which covered most of Canada and the United States in a blanket of ice fifteen thousand years ago. Within these ice-free areas, many plants and animals evolved—taking on characteristics different from their mainland counterparts.

Island topography can be divided into three regions: the Queen Charlotte Ranges stretch from Port Louis on the mid-west coast, south to Kunghit Island at the southern tip of the islands; the Skidegate Plateau stretches from Langara Island in the north, southeast to Louise Island; and the Queen Charlotte Lowlands encompass the northeast corner of Graham Island from Naden Harbour to just north of Skidegate.

Three fault lines run through the islands, making them prone to seismic activity, and the Islands hold the dubious record for the strongest recorded earthquake in Canada—an 8.1 that hit in 1949.

The climate is strongly moderated by North Pacific maritime conditions. Seasonal temperatures vary little and precipitation is common throughout the year. Summers are cool and relatively dry compared to the winters, which are mild with heavy precipitation. Some of the strongest winds

in Canada have been recorded at Cape St. James at the southern tip of the islands. The Queen Charlotte Mountain Range, running north–south along the west coast "backbone" of the islands, acts as a barrier, shielding the populated east coast of the islands from much of the precipitation. The east coast receives as little as one third the precipitation of the west coast: weather records show an average of 3218 millimetres (126 inches) of annual precipitation in Tasu Sound, on the west coast, and only 1216 millimetres (48 inches) in Tlell, on the east coast.

The islands are separated from mainland British Columbia by Hecate Strait, a shallow body of water that averages about 100 kilometres between shores. During some periods in the islands' history, a portion of this area was exposed and a large grassland stretched at least half way across the strait. According to some anthropologists, it was during this time that people found their way from Asia and eventually settled the continents of North and South America.

The best place to have an encounter with the world's largest black bear is safely inside a car on the many logging roads that criss-cross the landscape.

THE HAIDA

People began inhabiting these islands possibly as far back as 13,000 years ago, and eventually developed a culture made rich by the abundance of the land and sea. These people became the Haida, a linguistically distinct group with a complex class and rank system, consisting of two main clans: Eagles and Ravens. Connections and diversity within the nation were attained through a system of cross-lineal marriage between the clans. This system was also important for the transfer of wealth within the Nation, as each clan was reliant on the other for the building of longhouses and the carving of totem poles and other items of cultural importance.

Noted seafarers, the Haida occupied more than 100 villages throughout the islands. They were also skilled traders, with established trade links with neighbouring First Nations on the mainland and farther afield. The Haida had a stable existence and a vibrant culture at the time of European contact.

CONTACT AND TRADE

The first European to sight Haida Gwaii was a Spaniard, Juan Perez, on July 17, 1774. Blown off course, his crew aboard *Santiago* had not seen land for several days when they sighted what is now known as Langara Island, a small island off the northwest tip of the archipelago. Perez was under orders to claim new lands in the name of Spain to prevent the feared expansion of Russian territory south along the coast. Perez ventured close enough to observe several large buildings along the shore and to conduct some trade with local Haida, who paddled out in enormous canoes, each carved from a single tree. Because of bad weather, Perez soon departed and returned south without setting foot on shore or assigning a name to his discovery.

The islands were left unnamed by European explorers until 1787, when Captain George Dixon, under orders to claim new lands and to investigate trade opportunities for Britain, and named them after his ship, *Queen Charlotte*.

Europeans paid little attention to the islands, until they recognized the value of the abundant sea otter pelts found there. These pelts, each worth a small fortune and highly prized in China, initiated a flourishing trade between European traders and the Haida, who quickly discovered the potential wealth the trade could bring. To take control of the area's fur resources, the Europeans set up trading alliances, which contributed to the exchange of cultures and trade goods.

HAIDA GWAII · Queen Charlotte Islands

The moon rises over Sandspit and the famous Balancing Rock – a stone's throw from Skidegate.

The trade in sea otter pelts was at first harmful only to the sea otters, but as the resource became scarce, trade became more cutthroat and destructive. Experienced traders, the Haida did well initially, bringing new wealth almost overnight. Haida clan chiefs spent their new-found wealth on longhouses, totem poles, and potlatching. The potlach ceremony concludes with the distribution of the host chief's possessions to the attendees, a demonstration of his status and his confidence in the clan's ability to continue amassing wealth.

Greed on all sides soon led to the extinction of the sea otter from the waters around the islands, and trade shifted to cultural objects and furs of lesser value. With the decline of the sea otter, trading slowed and missionaries filled the void, eager to convert a nation that didn't fit into European categories of experience or understanding.

European diseases like tuberculosis and smallpox were transferred to the Haida, who, with no inherited immunity, rapidly succumbed. Within a few decades, the Haida Nation was decimated, with mass deaths and the loss of entire villages. Outside pressures from missionaries and the colonial government, combined with the deaths of so many members, eventually forced the abandonment of almost all of the nation's villages, and the relocation of the remaining Haida to the communities of Old Massett and Skidegate Mission. From an estimated seven thousand Haida at contact, fewer than seven hundred found their way to these two villages.

SETTLEMENT

With the Haida Nation in a state of upheaval and suppressed through various methods of forced assimilation, the islands soon found themselves at the mercy of a newly formed Canadian government. To prevent the United States from expanding north into this unpopulated and unprotected territory, the Canadian government began acquiring lands and populating them with immigrants. Returning veterans of World War I were encouraged to settle on the Queen Charlottes, and were given large land grants in the hopes that they would develop an agricultural base for the islands. Many settlers attempted farming, but the distance from markets, a poor international economic climate, and the lack of quality agricultural lands doomed these ventures. Within a few decades, nearly all the farms had been abandoned.

Those settlers who took up fishing had better prospects. The islands' proximity to the nutrient richness of the continental shelf made them an ideal centre for the fishing industry. Salmon, halibut, crab, razor clams, and other species all contributed to the development of a lucrative local industry. Many canneries and processing plants developed around the islands, including whaling stations in Naden and Rose Harbours. With their maritime background, many Haida adapted to this new economy and began profitable ventures building boats and fishing. Masset developed a lively harbour where work was abundant and profitable.

The readily accessible stands of western red cedar and sitka spruce provided another catalyst for European settlement in the area. During World War II the tight-grained, shatter-resistant Sitka Spruce was of particular importance for airplane manufacturing. As a result, logging increased significantly to support the Allied war effort. Communities like Sandspit, Queen Charlotte City, and Port Clements developed and thrived, attracting families and establishing services.

HAIDA GWAII TODAY

Logging continued at a rapid pace for decades, until blockades by the Haida Nation and international pressure forced the governments of British Columbia and Canada to lower the allowed cut rate and to create the Gwaii Haanas National Park and Haida Heritage Site. In keeping with the islands' reputation for uniqueness, this national park is the first in Canada to be co-managed by a joint board of a First Nation and the Canadian government. In 2005 Gwaii Haanas (Islands of Wonder) was named the best national park in North America, in recognition of its isolation and ruggedness, its unique natural endowments, and the ancient Haida village sites scattered throughout. The park also protects the village of SGaang Gwaay, a UNESCO World Heritage Site that features some of the best preserved totems and longhouse remains in a natural setting.

Communities on the islands have risen and fallen with the changing resource economies typical of the BC coast. Many once-bustling communities in remote places around the islands have been abandoned because of economic shifts.

Today, there are seven communities on the islands. These are concentrated almost exclusively on Graham Island, with the exception of Sandspit, which is on the north side of Moresby Island. Sandspit is connected to the other island communities by a short ferry crossing that connects to Highway 16, the Yellowhead Highway, which runs along Graham Island's east coast. Changes in the logging industry have forced Sandspit to change its focus over the past few years; the community has recently constructed a sheltered harbour and is developing its

tourist potential. There are regular scheduled flights from Vancouver to Sandspit International Airport.

The Village of Queen Charlotte, a government administration centre at the southern end of Graham Island, became the islands' third and newest municipality after the village's first election in November 2005. Many use the community as an embarkation point on their journeys south into the national park.

Skidegate is located seven kilometres north of Queen Charlotte and is one of two Haida communities on the islands. Ferry service from Prince Rupert, crossing Hecate Strait, arrives at Skidegate Landing on the edge of the community. The Qay'llnagaay Heritage Centre, which houses the Haida Gwaii Museum, is currently under construction and will be a feature attraction for future visitors.

Tlell, located halfway along the coast, is the islands' most agrarian community and includes the islands' only cattle ranch and veterinary clinic. Many island artisans display their crafts in small stores along well-marked roads just off the highway.

From Tlell, Highway 16 leaves the coast and makes a straight dash northwest to the community of Port Clements, at the base of Masset Inlet. Another of the islands' municipalities, Port Clements is suffering from the downturn in logging, its primary economic activity. "Port," as it is known, is nevertheless a picturesque community that boasts some of the islands' best sunsets. It also features a municipal campground and shoreline walk on the edge of town.

Masset is the oldest of the island municipalities. Combined with its close neighbour, Old Massett, it is the islands' largest population centre. Once home to a strong and vibrant commercial fishing industry, Masset has made changes to accommodate the sportfishing industry that has developed in recent years. Masset was also home to a large Canadian Forces base that was dramatically downsized in 1995. When the military departed, its assets—including a recreation centre and more than 150 homes—were donated to

Haida Children.

the community. There are regularly scheduled flights between Vancouver and Masset Municipal Airport.

Old Massett is situated beside Masset and is connected by a road and a well-used sidewalk. The other Haida community on the islands, Old Massett is home to many talented Haida artists. Several longhouse-style buildings are under construction in an effort to rekindle cultural traditions and provide artists with space to display their works. The first modern totem pole was raised at Old Massett in 1969, marking the resurgence of the Haida Nation.

Today the islands draw tourists from around the world who are lured by the isolation, landscape, impressive culture, and outdoor activities that are

offered here. The spectacular scenery hints of a time before human arrival. The rugged shorelines, stands of huge trees, and vast, sandy, unpopulated beaches offer the visitor a relaxed atmosphere where one can easily find peace in natural surroundings.

The inhabitants of the islands recognize that our future as a species is intrinsically linked to the protection of our environment, the wise management of our resources, and the beauty of our landscape. It is this ecological balance that makes the islands such a wonderful place to live, and offers visitors the opportunity to discover an exceptional place at the edge of the world.

Land of Mountains, Mist and Myth

◂ A ray of light strikes one of the hundreds of bald peaks that form the backbone known as the San Christoval Range in Gwaii Haanas National Park Reserve and Haida Protected Site.

▴ A walk in the rainforest near Juskatla, where moss grows everywhere and on anything, is a humbling experience.

Land of Mountains, Mist and Myth

◄ A setting sun on the wide expanse of North Beach, near Masset, sets the clouds afire.

▲ Slippery kelp can be found in abundance along the coastlines.

HAIDA GWAII · Queen Charlotte Islands

Land of Mountains, Mist and Myth

▲ A pod of humpback whales enjoys a lunchtime feeding off the coast of the Queen Charlotte Islands/Haida Gwaii.

◂ Collectors will admire the many types of shells washed up on Bonanza Beach in Rennell Sound.

▸ A sea of logs and driftwood flows along North Beach to the basalt pillar of Tow Hill.

HAIDA GWAII · Queen Charlotte Islands

Land of Mountains, Mist and Myth

◄ Waiting for the Big One! A lone fisherman near Coho Point, Langara Island.

▲ Beachcombing on Agate Beach near Masset can uncover all sorts of rock treasures.

Land of Mountains, Mist and Myth

▲ Beresford Creek on the western coast of Graham Island is hemmed in by a luscious green forest as it meanders to the sea at Beresford Bay.

◂ Burnaby Strait is the narrow channel between Burnaby Island and the main archipelago of Gwaii Haanas. At low tide the narrows become a nursery to hundreds of sea creatures that survive under the unique intertidal conditions.

▸ These towering moss-covered Sitka spruce thrust skywards along the Yakoun River.

HAIDA GWAII · Queen Charlotte Islands

Land of Mountains, Mist and Myth

◂ All tied up—a fishing boat in Port Clements. ▴ Islets seem to rise from the sea to dot the bay of Port Louis.

HAIDA GWAII · Queen Charlotte Islands

Land of Mountains, Mist and Myth

◂ Helicopter beachcombing is one of the best ways to explore the rugged coastline of Haida Gwaii/Queen Charlotte Islands.

▴ A carved Watchman looks out over Port Louis Bay and protects the Outpost from any danger. Situated in a wilderness setting, the Outpost, part of the West Coast Fishing Club (a collection of fishing lodges), is a pristine location for salmon and halibut fishing.

Land of Mountains, Mist and Myth

◂ Port Clements, or "Port," as the locals call it, has some of the most magnificent sunsets in the Queen Charlotte Islands/Haida Gwaii.

▴ Greying bones, rocks, shells, and driftwood are all treasures to be scrutinized at Bonanza Beach, Rennell Sound.

Land of Mountains, Mist and Myth

◂ Lina Island and the Queen Charlotte Mountain Range are mirrored in Skidegate Inlet.

▸ The dance of the Ravens at a potlatch ceremony in Old Massett.

HAIDA GWAII · Queen Charlotte Islands

Land of Mountains, Mist and Myth

◂ A seaplane in Queen Charlotte city awaits a day of aerial adventures.

▴ Early morning rain and mist enshroud a forest on the banks of Masset Sound.

Land of Mountains, Mist and Myth

◄ The receding tide leaves behind a rippled pond of sand and sea on North Beach.

▸ The rocky outcroppings and crashing surf near Cape Knox on the northwestern tip of Graham Island are a characteristic feature of the coastline.

HAIDA GWAII · Queen Charlotte Islands

Land of Mountains, Mist and Myth

◂ The remains of a fishing vessel washed ashore at North Beach. According to Haida legend, this is where Raven first coaxed men out of a clamshell, making it the site of creation.

▴ A ceremonial potlatch in Old Massett.

Land of Mountains, Mist and Myth

◂ Abandoned more than a century ago, this partially carved Haida cedar canoe sits silently in the forest near Juskatla. The canoe, which is over fifteen metres long, is accessible along a boardwalk and sign-posted trail.

▴ A lone bald eagle soars over the pristine beaches of Lepas Bay.

HAIDA GWAII · Queen Charlotte Islands

Land of Mountains, Mist and Myth

▲ A weathered and sun-bleached totem pole depicts a beaver in Nan Sdins (Ninstints) village, SGang Gwaay, Anthony Island.

◂ The Old Massett cemetery is a solemn reminder of a culture ravaged by smallpox in the late nineteenth century.

▸ St. Mary's Spring in Tlell is a saintly looking wood carving beside a bubbling creek. Legend has it that if one drinks from the waters of the spring, one is destined to return to the islands. In this case, an individual, anxious to have the prophecy come true, has placed an offering of chocolate within the cross's cracks.

HAIDA GWAII · Queen Charlotte Islands

Land of Mountains, Mist and Myth

◂ The silhouette of Flower Pot Rock at low tide in Henslung Bay, Langara Island.

▸ Surging seas pound the coastline below Langara Lighthouse on Langara Point.

Land of Mountains, Mist and Myth

◂ Early signs of autumn at the Fish Hatchery waterfall near Moresby Camp.

▴ Fallen leaves on the Yakoun River appear to be clinging to the reflecting tree branches.

HAIDA GWAII · Queen Charlotte Islands

Land of Mountains, Mist and Myth

◂ After a day of salmon fishing, guests of the popular West Coast Fishing Club in Henslung Cove, Langara Island, race back to weigh their catch and to see if they have caught a tyee—a salmon weighing over thirty pounds (thirteen kilograms).

▴ A humpback whale waves goodbye as it gracefully dives below the sea.

HAIDA GWAII · Queen Charlotte Islands

Land of Mountains, Mist and Myth

◂ Pillar Rock, a sea stack off Graham Island near Naden Harbour, rises over thirty metres and is topped off by several trees perched precariously on its edge.

▸ A ceremonial mask is danced for guests at a Haida potlatch in Old Massett.

HAIDA GWAII · Queen Charlotte Islands

Land of Mountains, Mist and Myth

◂ A low tide near Fury Bay on the west coast of Langara Island reveals kelp-covered islets.

▴ Cranberry picking is a favourite pastime of the locals in the fall.

HAIDA GWAII · Queen Charlotte Islands

Land of Mountains, Mist and Myth

◂ A brilliant golden sunset is reflected in Cloak Bay and Henslung Cove, Langara Island.

▴ At low tide the rocky shorelines display a host of seaweeds, barnacles, and peculiarly shaped forms of sea vegetation.

39

Land of Mountains, Mist and Myth

◂ Rocks and boulders of all shapes, sizes, and colours litter the beaches near Tlell.

▴ Ominous clouds cover North Beach, with Tow Hill off in the distance.

HAIDA GWAII · Queen Charlotte Islands

Land of Mountains, Mist and Myth

◂ A black tail deer in the Delkatla Wildlife Sanctuary is poised to dart into the surrounding forest.

▸ The Massett Airport mascot greets visitors arriving from all parts of the world.

43

◄ Highway 16 connects the communities of Masset in the north with Skidegate and Queen Charlotte city in the south. During the ninety-minute ride, it is not unusual to see black tail deer grazing on the side of the road.

▲ An avid angler casts a line on Riley Creek in Rennell Sound.

HAIDA GWAII · Queen Charlotte Islands

Land of Mountains, Mist and Myth

◂ The Delkatla Wildlife Sanctuary is home to over 150 species of migrating and resident birds. Early morning is the best time to see bald eagles, great blue herons, and Canada geese foraging for breakfast. The enclosure protects endemic plants from the introduced deer that forage in the sanctuary.

▴ A stellar sea lion basks on one of the thousands of rocky pinnacles that surround the Queen Charlotte Islands/ Haida Gwaii.

HAIDA GWAII · Queen Charlotte Islands

◂ A canopy of green covers the road to Gray Bay campsite.

▴ Five thirteen-metre-high totem poles at the Qay'llnagaay Heritage Centre in Skidegate. In total fourteen poles will grace the beach of Qay'llngaay to produce a world-class heritage site.

Land of Mountains, Mist and Myth

◄ Trawlers in Pillar Bay, North Graham Island.

▲ A potlatch ceremony in Old Massett is a time for celebration and coming together with the community.

HAIDA GWAII · Queen Charlotte Islands

Land of Mountains, Mist and Myth

◂ Tree trunks dripping with moss are reflected in a tranquil tidal pool near Lepas Bay, Graham Island.

▴ Moss-covered totem poles stand in the abandoned Haida village of Kiusta on the northern tip of Graham Island.

Land of Mountains, Mist and Myth

◂ Overlooking Tian Bay, Graham Island.

▸ A ferocious mask hangs on a tree in Tlell, an artists' community between Masset and Skidegate.

◂ A creek flows to the sea at Lepas Bay, along the northwest coast of Haida Gwaii.

▴ An eagle soars over a treetop, scouring the earth below for prey. Bald eagles are a common sight on the islands and can be seen flying majestically over many communities.

HAIDA GWAII · Queen Charlotte Islands

Land of Mountains, Mist and Myth

◂ Dusk arrives at East Beach in northern Naikoon Provincial Park.

▸ A great blue heron appears frozen in a tide pool in the Delkatla Wildlife Sanctuary. A refuge for over 150 different species of birds, the sanctuary is located in Masset and has several trails and observation towers.

HAIDA GWAII · Queen Charlotte Islands

Land of Mountains, Mist and Myth

◂ Solid pillars of volcanic rock sprout trees of various shapes and sizes on their peaks at Kusgwai Passage, Langara Island.

▴ An abandoned truck in Skidegate becomes a new home for plants and flowers, which grow in profusion on the mist-covered islets.

◀ Shafts of beautiful sunlight burst through dark clouds to reveal the majestic beauty of the islands, a common occurrence at Lina Island in Skidegate Inlet.

▲ Artisan Lon Sharp's copper and cedar coho salmon, situated near the airport, welcomes visitors to Sandspit, the gateway to Gwaii Haanas and the only settlement on Moresby Island.

HAIDA GWAII · Queen Charlotte Islands

◂ Light filters through an old-growth forest near the new Masset cemetery.

▸ The weather report in Tlell.

HAIDA GWAII · Queen Charlotte Islands

◀ A kayak glides through the still waters of Port Louis.

▸ The volcano-like peaks topped by trees, on Cox Island, are an ideal place for eagles to nest and observe their surroundings.

Land of Mountains, Mist and Myth

◂ The clear waters of Port Louis bay are an ideal place to kayak.

▴ Pacific salmon fight the strong currents of Pallant River near Moresby Camp, as they make their way to the place of their birth and begin a new cycle of life.

Land of Mountains, Mist and Myth

▲ "Twinned Beach," as the locals call it, is located south of Port Louis on Gillian Point.

◂ Defying the ravages of time, the mortuary poles of the abandoned Haida village of Nan Sdins (Ninstints), on SGang Gwaay in Gwaii Haanas National Park Reserve and Haida Protected Site, were declared a UNESCO World Heritage site in 1981.

▸ A cascading waterfall forms a ribbon of white water as it spills over from Lake Takakia near Mount Moresby.

Land of Mountains, Mist and Myth

◂ Raindrops create a mesmerizing pattern in a small pond in the Tow Hill Ecological Reserve a few kilometres outside of Masset.

▸ The rusting remains of the US army transport ship *Clarksdale Victory*, which ran aground in 1947, can be see on Hippa Island near Port Louis.

73

Land of Mountains, Mist and Myth

▲ A 200-foot stone outcropping rises from a white sandy beach at Cape Knox.

◂ A full moon rises over Alliford Bay.

▸ The dogfish totem pole by famed artist Bill Reid pierces the sky at the Skidegate Haida Immersion Program (SHIP) longhouse in Skidegate village.

75

HAIDA GWAII · Queen Charlotte Islands

Land of Mountains, Mist and Myth

◂ Retreating water at Bonanza Beach in Rennell Sound.

▴ The lighthouse keeper at the Langara Point lighthouse regularly inspects the fresnel light high atop the structure.

HAIDA GWAII · Queen Charlotte Islands

Land of Mountains, Mist and Myth

◂ The Outpost, nestled in the rain forests of Port Louis, western Graham Island, has all the comforts one could ask for after a tiring day of salmon fishing.

▸ A decorative Haida canoe off Raven Avenue in Old Massett awaits its maiden voyage across Masset Sound.

Land of Mountains, Mist and Myth

- Reflections in Port Louis, western Graham Island.

◂ Mounds of kelp are exposed at low tide on Cox Island.

▸ Towering trees—Sitka spruce, western red cedar, and Pacific hemlock—carpet the Queen Charlotte Islands/Haida Gwaii. Characteristic of the islands are trees in various stages of falling across river beds.

81

Land of Mountains, Mist and Myth

▲ Walking through the rainforests—where the trees soar high into the sky—one feels a sense of timelessness in the stillness and silence.

◂ A fishing boat traverses Skidegate Inlet between Alliford Bay and Queen Charlotte on a perfectly calm morning.

▲ A rotting tree stump in the Tow Hill Ecological Reserve is transformed into a bird-like figure covered in moss.

Land of Mountains, Mist and Myth

◂ Light shimmers over Juan Perez Sound and the San Christoval Range of mountains in Gwaii Haanas National Park.

▴ The harbour in Masset, alive with fishing boats.

Land of Mountains, Mist and Myth

◂ Fishing boats depart from the Queen Charlotte wharf at sunrise to get an early morning start.

▸ Haida drums are used in a ceremonial potlatch to honour community members and ancestors.

HAIDA GWAII · Queen Charlotte Islands

Southwest of Skidegate, Mount Rory, Snow Peak, Stripe Mountain, and Hump Mountain emerge from darkness at sunrise.